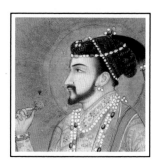

GREAT WORKS OF

INDIAN ART

Douglas Mannering

A Compilation of Works from the

BRIDGEMAN ART LIBRARY

SMITHMARK

Great Works of Indian Art

This edition published in 1996 by SMITHMARK
Publishers, a division of U.S. Media Holdings, Inc.,
16 East 32nd Street, New York, NY 10016.
SMITHMARK books are available for bulk
purchase for sales promotion and premium use.
For details write or call the manager of special
sales, SMITHMARK Publishers, 16 East 32nd
Street, New York, NY 10016; (212) 532-6600
First published in Great Britain in 1996 by
Parragon Books Limited
Units 13-17, Avonbridge Industrial Estate
Atlantic Road, Avonmouth, Bristol BS11 9QD
United Kingdom

© Parragon Books Limited 1996

ISBN 0-7651-9896-7

Printed in Italy

Editors: Barbara Horn, Alex Stace, Alison Stace, Tucker Slingsby Ltd
 and Jennifer Warner

Designers: Robert Mathias • Pedro Prá-Lopez, Kingfisher Design Services

Typesetting/DTP: Frances Prá-Lopez, Kingfisher Design Services

Picture Research: Kathy Lockley

The publishers would like to thank Joanna Hartleyat the Bridgeman Art Library
for her invaluable help.

Indian Art

'Indian art' is really shorthand for 'the art of the Indian sub-continent': that is modern India, Pakistan and Bangladesh. These political units are of course quite recent, and for most of history 'India' has satisfactorily described a geographical area, more often than not divided into many states.

The earliest Indian civilization is known only through archaeology. The Indus Valley culture, in the north-west, flourished between about 2500 and 1500 BC, and was evidently sophisticated and well organized. The small works of art that have been unearthed are fascinating, but their connection with any later period of Indian history is problematic.

At some point in the 2nd millennium BC, nomadic herders, known as the Aryans, descended through the passes of the north-west – always the main gateway into India for invaders – and occupied the northern plain from the Indus to the Ganges. The previous inhabitants were absorbed into Aryan society or driven down into the south of India.

For something like a thousand years, our only evidence about Aryan life lies in the *Vedas*, the earliest scriptures of Hinduism. Despite its long and complicated evolution, certain beliefs remained central to Hindu life – above all, the belief that the soul lives again and again, its lodging in each life depending on its past behaviour (*karma*). Equally durable was the caste system, which destined a person at birth to become a priest (*brahman*), warrior, freeman, artisan or slave.

Fuller historical records begin in the 6th century BC, when the

first breakaways from Hinduism occurred. Both the Buddha and Mahavira (founder of Jainism) were historical figures whose lives have been recorded; in their different ways, both sought to show the individual a way out of the cycle of rebirth, suffering and death, discarding much of the myth and ritual associated with Hinduism.

Buddhism, which would become one of the great world religions, made great headway in India, especially during the period when the Maurya dynasty united most of the sub-continent. The greatest of the Mauryas, Ashoka (c 273-227 BC), proclaimed his adherence to Buddhism on tall lion-headed columns that are effectively the earliest surviving works of Indian art since the Indus Valley era.

The long history of Indian sculpture really begins in the early centuries AD, with centres at Gandhara, Mathura and Amaravati producing mainly Buddhist works; those at Gandhara in the north-west, where Persian and Greek influences had been felt for centuries, were in a 'un-Indian' style often labelled Greco-Buddhist. The sculpture of the Gupta period (AD 320-c 550) is generally held to represent one of the peaks of Indian art, although centuries of varied achievement were to follow.

In the 8th century, Arab armies occupied the Sind, and from about AD 1000 a series of Muslim invasions devastated much of India. Unlike earlier Indian religions, Islam was monotheistic and exclusive, destroying the temples and monasteries of its rivals. Buddhism, long past its zenith, virtually disappeared from India, but Hinduism, with a more directly emotional hold on the lives of the people, proved more resistant.

Painting already had a long history, but most major early works (notably the Buddhist paintings in the caves of Ajanta) have survived only in a seriously damaged condition. Then, in the late medieval period, miniature painting took on a new importance, especially once paper had replaced palm leaves. Miniature

painting was by no means always small in format: the word comes from the Latin word for the medium once used, *minium* (red lead). The bold colours and stylized treatment of the Hindu miniature was submerged for a time by the Persian style introduced by the Mughals, Mongol-descended Muslim warriors who controlled much of India from about 1526. Modified by its new environment, the Mughal miniature brought a new and vivid realism to Indian art.

The decline of Mughal power in the 18th century led to the dispersal of the court artists and a final flowering of Hindu painting in the western and north-western (Punjab) states. The rise of a new imperial power, the British, hastened the decline of the Indian arts and, for better or worse, inaugurated a new phase in the history of the sub-continent.

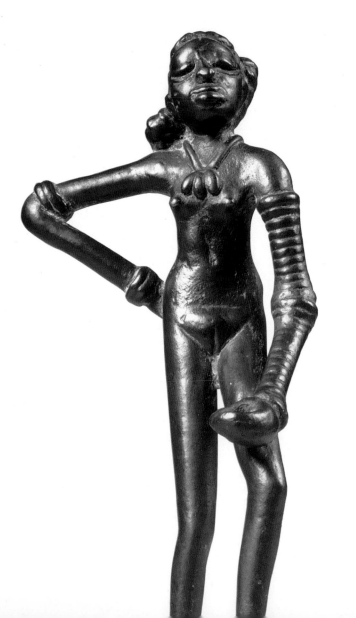

◁ **Young Woman**
c 2300-1750 BC

Copper

THIS ELEGANT, ALOOF CREATURE is often described as a dancing girl, although in reality we know nothing definite about her. Hers is the only metal figure so far recovered from the remains of India's first civilization, centred on the Indus Valley (modern Pakistan) and flourishing between about the mid-first and mid-second millennium. The very existence of the Indus Valley civilization was unsuspected until the mid-19th century, but excavations in the 20th century have shown that it supported large cities such as Harrappa and Mohenjo-Daro (where the figure was found), although these are modern labels, since the Indus Valley script has never been deciphered. Moreover, these sites were models of town planning, based on a grid system like that of New York, with an astonishingly capacious 'great bath' (presumably for ritual purposes) and a high citadel.

▷ **Head of a Camel**
c 2300-1750 BC

Terracotta

LIKE THE *YOUNG WOMAN* (opposite), this characterful head was found at Mohenjo-Daro, one of the chief centres of the Indus Valley civilization. The potter who shaped and fired it must have had considerable insight as well as technical skill, since he succeeded brilliantly in conveying the essential characteristics of the camel – its look of cud-chewing bad temper – while simplifying but not caricaturing the form of its head. All the works of art so far excavated from the Indus Valley sites are small (less than 20 cm/ 8 in high) and too limited in number to make serious judgements about: one copper figure, a few terracottas, and some figure carvings in steatite (soapstone, a very easily worked material). Much more numerous are little square seals made of steatite and engraved with brief pieces of script and splendidly observed buffaloes, elephants, rhinoceroses and other creatures; examples of these were found in Mesopotamia, indicating that the Indus Valley had trade contacts with the Near East in ancient times.

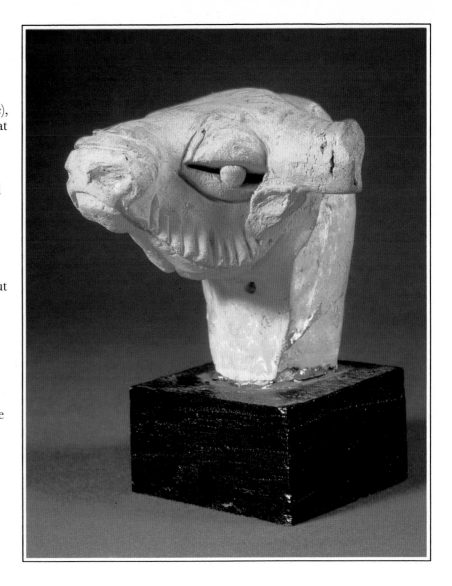

▷ **Head of a Foreigner**
3rd century BC

Sandstone

AT SOME POINT in the 2nd millenium BC the Indus Valley civilization collapsed. The causes are unknown, and it is not even clear whether the collapse was sudden or gradual. During the same long, obscure period, a new people, the Aryans, came down into India through the passes of the north-west and occupied most of the sub-continent. With them they brought the Vedic religion from which Hinduism developed; but they seem to have had no art, and to have positively distrusted image-making. For a thousand years or more the record is virtually blank, until the spectacular rise of the Maurya dynasty led to the production of a mainly Buddhist art. This carving comes from Sarnath, a particularly significant spot because it was where the Buddha preached his first sermon. The polished appearance of the head is characteristic of Maurya art, produced by buffing the stone.

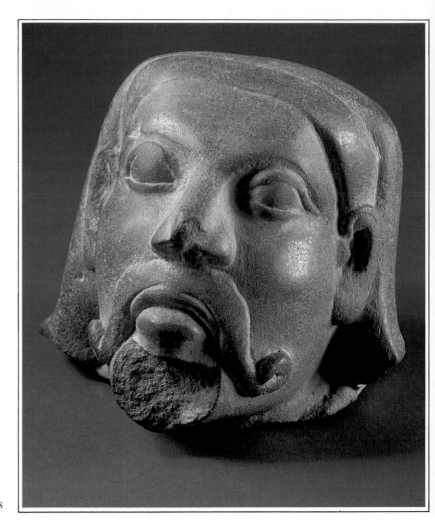

▷ **Yakshi** 2nd century BC

Terracotta

THE ARTISTIC REVIVAL that took place under the Maurya dynasty seems to have been a vigorous one, but relatively few works have survived from the period. The best-known objects are the pillars of carved and polished stone, raised by the Buddhist emperor Ashoka (c 273-232 BC); the relief carvings on Buddhist buildings (page 13); and a number of carvings of *yaksha* and *yakshi*. These were nature spirits, images of fertility and abundance whose origins were in local cults rather than the great religions. However, they were quickly incorporated into Buddhism and Hinduism; the *yakshi*, or female spirits, were often extremely voluptuous (page 16), and their appearance among the decorative devices on Buddhist buildings is liable to surprise a westerner, accustomed to a more rigid demarcation between spirit and flesh. The figure shown here is a rather unusual *yakshi* from Ahichchatra in northern India, elegantly dressed and taking up a stance that suggests an acquaintance with courts rather than hill and stream.

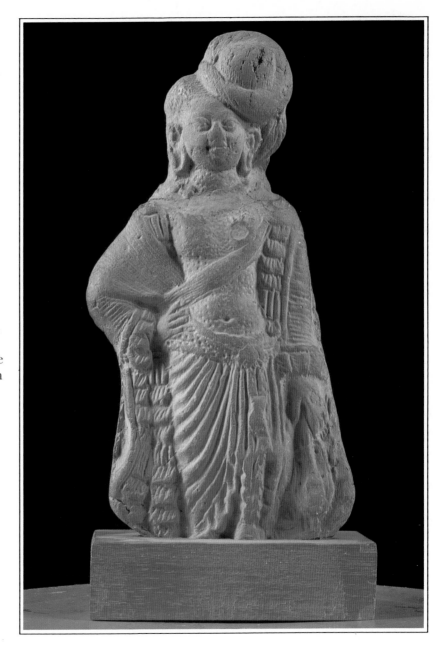

▷ **The Buddha**
c 3rd century AD

Schist

IN THE 6TH CENTURY BC, a new Indian creed was founded by Siddhartha Gautama. Born around 560 BC, Gautama belonged to the high-ranking warrior caste and grew up in comfortable circumstances. But, confronted with the facts of suffering and death, he embarked on an earnest quest for spiritual knowledge. Practising austerities brought him no nearer to the truth, but after meditating for 49 days under the Bodhi tree he experienced his awakening. Gautama became the Buddha ('Enlightened One') and spent the rest of his life preaching detachment from desire and a Middle Way between asceticism and indulgence. In the centuries following the Buddha's death (c486 BC) his teachings became widely popular, especially when they found a patron in the Mauryan emperor Ashoka, whose celebrated pillars record his remorse for the blood shed in his wars. For five centuries no image of the Buddha was permitted in Buddhist art, although symbols often indicated his presence. This grey schist head is in the Greco-Buddhist Gandhara style.

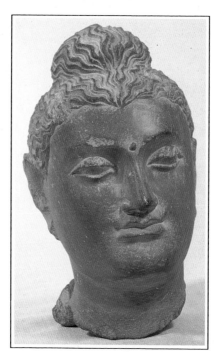

▷ **Lintel from Sanchi**
Early 1st century AD

Sandstone

ONE OF THE MOST IMPORTANT buildings in Indian Buddhist devotion is the *stupa*, which is essentially a monumental domed structure with a railing round it. It developed from the pre-Buddhist burial mound, and is still associated with death – or rather with the Buddha's release from the cycle of desire and suffering, for on his death he attained Nirvana. A *stupa* contained relics of the Enlightened One, and worshippers walked all round the interior as part of their devotions. The pillars, door and window frames and railings were lavishly decorated in low relief (that is, with the carved figures standing out only shallowly from the background). The Great Stupa at Sanchi is one of the most celebrated of early Buddhist *stupas*, built between the 3rd century BC and the 1st century AD. This lintel carries a carved figure of a fantastic animal, the griffin, sitting on a scroll. On the other side of the scroll is a surface carved in relief, with stylized plants, a woman, and a finely observed elephant.

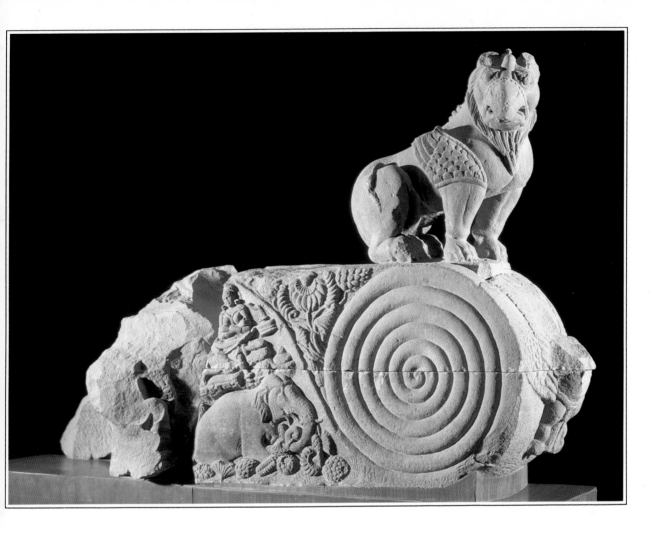

14

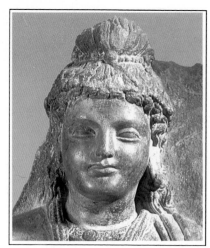

Detail

▷ **Maitreya** 2nd century AD

Schist

DURING HIS LIFETIME, the Buddha
expounded a philosophy rather
than a set of religious doctrines,
and presented himself as a purely
human teacher. Later, legends
grew up around all his doings, and
he was in effect regarded as a god.
He was also said to have been the
25th in a line of buddhas, each
sent to enlighten humanity when
the truth became forgotten. A
succession of buddhas implied the
existence of a Buddha of the
Future, or Maitreya, who is
portrayed in this grey schist statue.
Its missing right hand was
doubtless making a sign of
benediction, while the left holds a
water-flask, symbolizing the future.
Like the Buddha on page 12, this
one is carved in the Gandhara
style, which developed in north-
western India as a result of contacts
with the late Greek ('Hellenistic')
style which permeated the Middle
East; hence the un-Indian
physiognomy of these sculptures,
which are usually described as
Greco-Buddhist. The drapery,
though Hellenistic in treatment, is
Indian in arrangement, leaving the
chest bare.

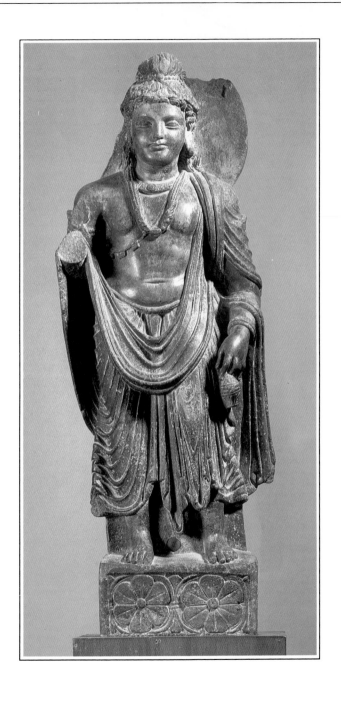

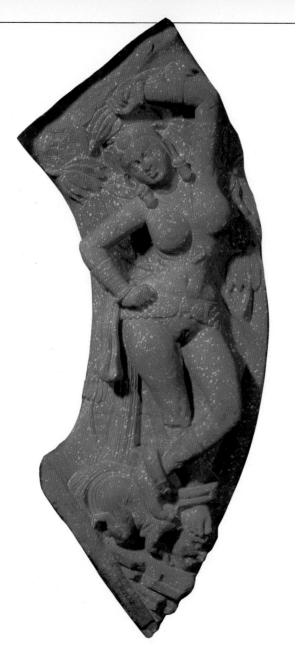

◁ **Yakshi** 1st century AD

Sandstone

THIS IS SOMEWHAT LATER in date
than the *yakshi* from Ahichchatra
(page 11), but the carving style
has become bolder and the forms
– notably the large breasts and
the hips – are much rounder and
more sensuous. In this example
the *yakshi* is shown grasping a
branch and standing in the
tribangha or triple-bend pose,
which became one of the most
familiar motifs in Indian art; so
did the pearl hip-belt, the
necklace and the absence of any
substantial clothing. Despite its
monumental air, the figure is
quite small, appearing on a door-
handle found at Mathura, which
became the greatest art centre in
northern India during the early
centuries AD. The material used
was the local pink sandstone,
whose distinctive feature – a
generous sprinkling of pale spots –
is clearly visible here. The *yakshi*
set the pattern for other female
types in carving, notably the
shalabhanjika, the devastatingly
beautiful woman who can make a
tree blossom merely by touching it
with her foot.

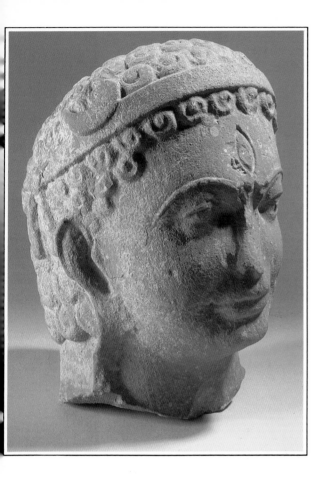

◁ **Head of Shiva**
1st century AD

Sandstone

THIS HEAD COMES FROM Mathura, one of India's three main artistic centres during this period. At Gandhara, in what is now Afghanistan, a 'Greco-Buddhist' style developed which influenced artists at Mathura, far away (about 130 km/80 miles below Delhi) in northern India. The reason was that both centres were part of the Kushan empire which stretched across the north-west and the north; Peshawar, in the north-west, was the Kushan capital, but their winter residence was at Mathura. In many respects Mathura sculpture remained independent of Gandharan influence, but contacts between the two may explain why Mathura produced its earliest images of the Buddha at about the time that such images also appeared in the north-west. Here, some Greco-Buddhist elements (for example, the curly hair) have even been transferred to a head of the Hindu deity Shiva, shown with a crescent-moon ornament and a vertical 'third eye' in the middle of his forehead.

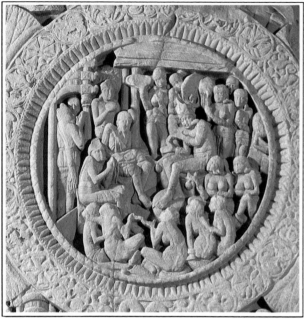

Detail

▷ **An Episode from the Life of the Buddha** 1st century AD

Limestone

DURING THE EARLY CENTURIES AD, Amaravati was the third great centre of Indian sculpture. Unlike Gandhara and Mathura, it was well beyond the influence of the Kushans: Amaravati belonged to the Andhra kingdom much further south, situated not far from the south-east coast of India. The great Buddhist *stupas* in the region were particularly lavishly decorated, and although they have been destroyed, superb reliefs have been recovered from the remains. They show that the Amaravati style was less 'classical' but more lively than that of its northern counterparts. The figures are less thick-set, although the sensuality of the females is extremely potent. The scene is crowded, and so arranged that the eye travels restlessly across it, creating a strong sense of movement; outside the picture, every available space is filled with plant and other decorative patterns. Such impressions of teeming, superabundant life recur again and again in Indian sculpture and architecture.

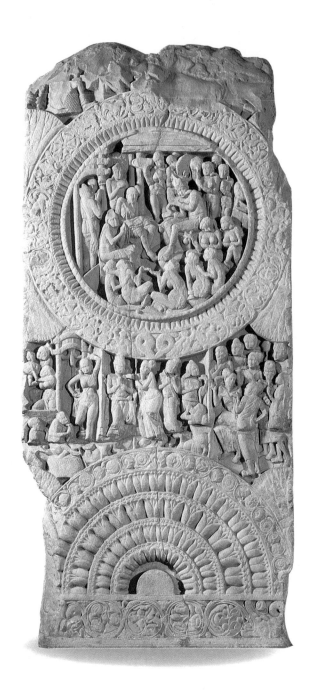

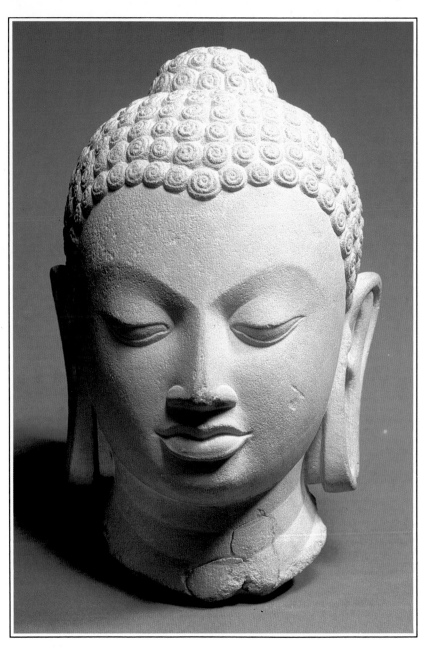

◁ **Head of the Buddha**
5th century AD

Sandstone

UNDER THE GUPTA DYNASTY (320-c 550), Indian sculpture achieved its 'classic moment', encapsulated in this work from Sarnath. Everything inessential has been eliminated from the face, so that the noble features of the Buddha are not overwhelmed by the stylized, decorative treatment of the hair. Though nowhere 'realistic', the head conveys an impression of inner life and spiritual concentration. The elongated ear-lobes are a convention, reminding the viewer that, before his great renunciation, the Buddha had once lived the life of a prince, his person weighed down by precious ornaments. His 'top knot' represents a cranial protruberance said to indicate the possession of exceptional spiritual insight. A great centre of Buddhist Gupta art, Sarnath had been a holy city ever since the Buddha himself, having achieved enlightenment, chose to give his first sermon there.

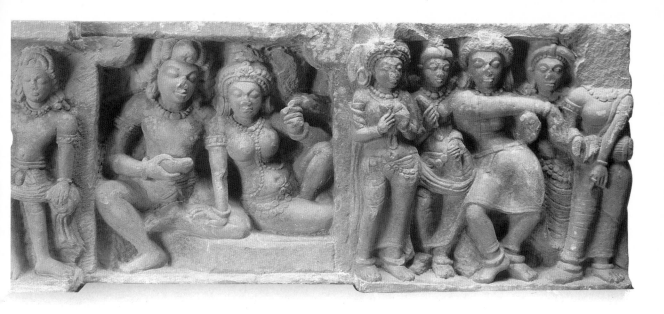

△ **Spectators** 5th century AD

Sandstone

BUDDHIST ART ACHIEVED a classic perfection during the Gupta period (opposite) but by its end the Buddhist religion was beginning to decline on the Indian sub-continent, although it had a great future before it in many other parts of the Far East. By contrast, Hinduism underwent a great revival, eventually absorbing Buddhism into its own complex religious and social system. Hindu sculpture also flourished under the Guptas, the most celebrated works being carved on the now-ruined walls of the Dashavatara Temple at Deogarh in central India. These portrayed the main Hindu deities, including a splendid recumbent Vishnu dreaming the universe into existence. This is a less portentous relief from Deogarh, showing lovers sitting at their ease, enjoying the delights of wine and the performances of musicians and dancers.

Detail

▷ **Mahavira** 6th-7th century

Painted panel

INDIA IS FAMOUS as the birthplace and battleground of great religions. Buddhism was in a sense a reaction against Hinduism, accepting its doctrine of reincarnation but rejecting the caste system and reliance upon a pantheon of gods. Remarkably, a near-contemporary of the Buddha, Mahavira (c540-468 BC), also preached a new doctrine and founded a new religion, known as Jainism. Mahavira shared the Buddha's indifference to the caste system, but laid more emphasis on an austere set of personal standards. A striking feature of his teaching is the absolute sacredness of life (*ahimsa*), which prompts Jains to do everything possible to avoid harming any creature, however microscopic. The portrait of Mahavira comes from a sanctuary in Khotan, just north of present-day Kashmir. Although a recorded historical figure, he has already been transformed into a godlike being with four arms, dwarfing the two bullocks beneath his throne. Like so many early Indian paintings, this one is in poor condition.

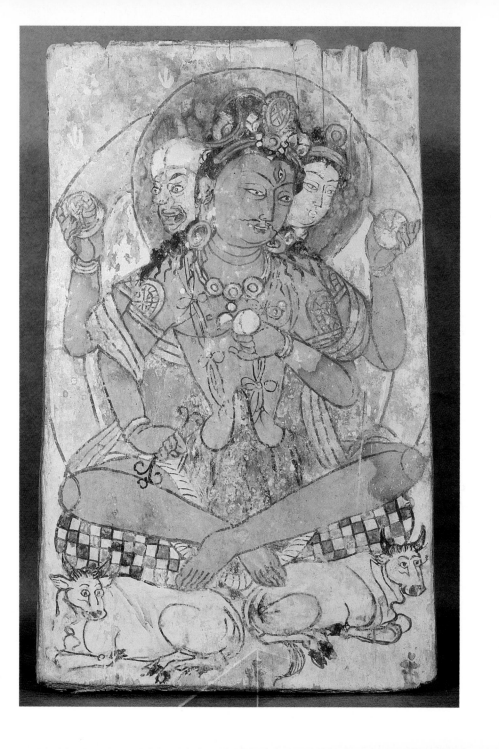

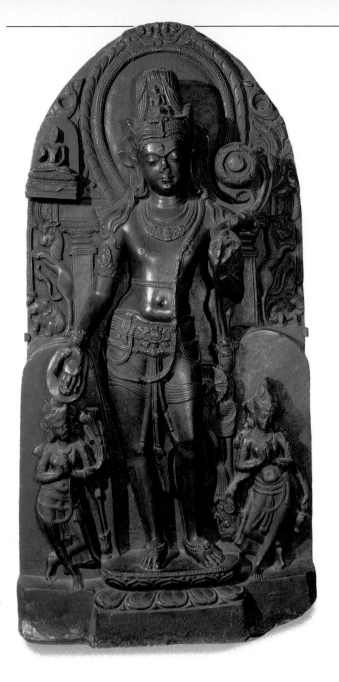

◁ **Avalokiteshvara**
9th-10th century

Basalt

THIS GODLIKE BEING, looming over his devotees in very much the same way as a Hindu deity like Sarasvati (page 26), illustrates the evolution of Buddhism away from its original simplicity. Avalokiteshvara, 'the Lord who looks down', is one of the *bodhisattvas*, enlightened beings who were first shown in art as the Buddha's companions. The *bodhisattva* had accumulated so much merit that he was capable of attaining Nirvana, but delayed his entry into bliss in order to help 'humankind. However, Avalokiteshvara, like the Maitreya (page 14) and even the Buddha himself, acquired the trappings and aura of a god – which, ironically, weakened Indian Buddhism, since it became less distinct from Hinduism and ill-equipped to survive the onslaught of Islam. This basalt figure from eastern India shows Avalokiteshvara with his conventional attributes, notably a seated figure of the supreme Buddha (*Amithaba*) in his crown and a large, stylized lotus in his left hand.

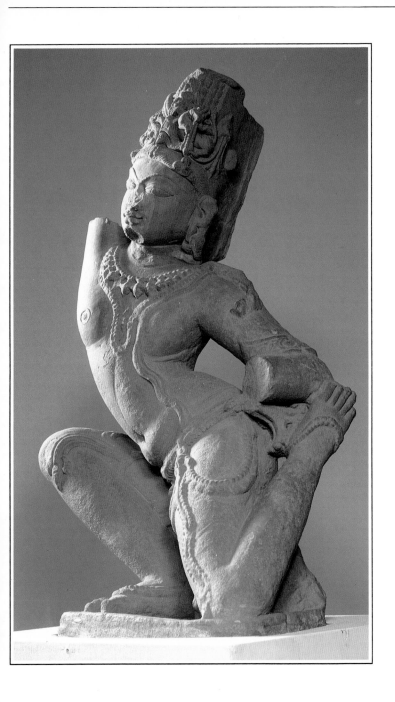

◁ **Harihara Dancing**
10th century

Stone

DESPITE ITS DAMAGED CONDITION, this is a fascinating work, strongly reminiscent of a dancer performing in a modern ballet; in particular, it resembles the kind of pose taken up by the famous Nijinsky. Music and dancing were central features of Hindu ritual, in the great temples and also at the level of village festivals. Indian music achieved a complexity and sophistication that has only recently been recognized in the West, while dancing has always had a dramatic and symbolic function, so that every pose and gesture is meaningful. Ultimately, the entire cosmos could be understood in terms of the dance (page 28). Harihara is a composite deity, half Vishnu (Hari) and half Shiva (Hara). This sculpture comes from the territory of the Pratihara dynasty in central India; other splendid carvings of the god and his doings survive on the walls of the ruined temple to Harihara at Osian in Rajasthan.

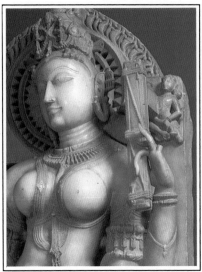

Detail

▷ **The Goddess Sarasvati** 12th century

Marble

SARASVATI IS THE CONSORT OF BRAHMA, 'the father of gods and men' and the principal deity in the Hindu trinity. Although she seems to have originated as a river goddess, her great role is as Sarasvati Vagdevi, 'goddess of speech'. Since recitation and declamation were central to the religious and scholarly tradition, this associated her with intellectual pursuits, and she is credited with the invention of the Sanskrit alphabet and the patronage of poetry, music and learning. The blurred lines between Indian religions are illustrated by the fact that this statue was actually made in Rajasthan by Jain craftsmen. As usual, the goddess is portrayed as a beautiful young woman with four arms, carrying various symbolic objects. Surrounded by small attendants and devotees, she holds up the prime symbol of literature and art, a book whose manuscript pages were made from long palm leaves, sewn together and 'bound' in wooden boards.

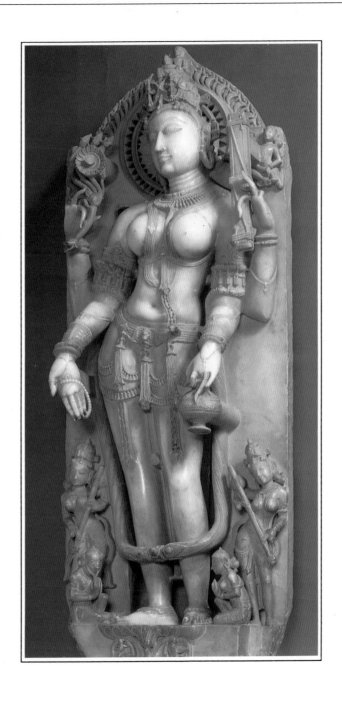

Detail

▷ **Shiva Dancing** 12th century

Bronze

A DISTINCTIVE ARTISTIC TRADITION developed in the south of India, where the inhabitants were Dravidians, mainly descended from the pre-Aryan population. At a time in the Middle Ages when Indian art was tending to become stale, the Dravidians produced bronze sculptures that were outstanding in their balance and harmony. These qualities are maintained in this famous image of the god Shiva as the Lord of the Dance, despite the difficulties involved in his possession of four arms. The hoop of flames represents the cosmos, for when Shiva dances, one world dies and another is born. This is symbolized by the drum and the flame which he holds in his upper hands. He dances on a demon dwarf, representing ignorance, and among his outspread hair floats the figure of Ganga, goddess of the Ganges, who looks on the Lord of the Dance with her hands placed together in an attitude of worship.

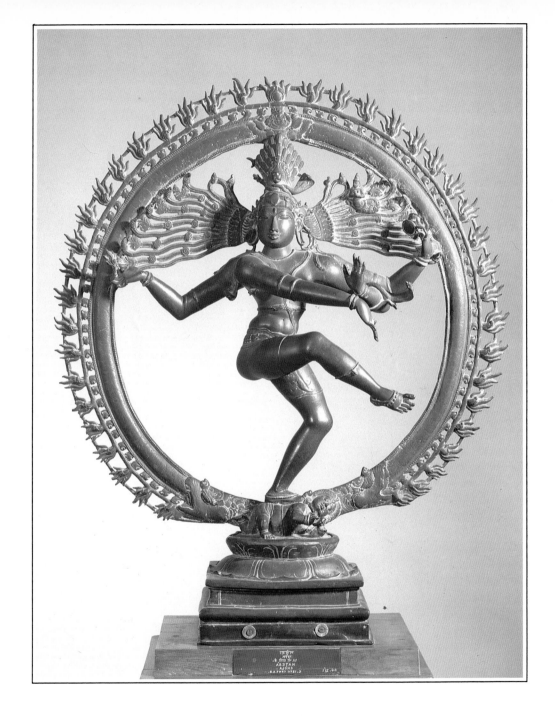

NATESA
CHOLA
C. 11TH CENT. A.D.

▷ **The Goddess Kali**
12th century

Bronze

LIKE HER DANCING HUSBAND
Shiva (page 28), this figure of
Kali comes from the south of
India; it provides an even better
example of the classical simplicity
of the Dravidian bronzes
produced during the Chola
period (9th to 12th centuries).
Hindu gods and goddesses exist
under many names, each
representing one or more facets
or incarnations of the divine.
This fact reflects the Indian
conviction that contraries – good
and evil, birth and death,
creation and destruction – are
only aspects of a single
undifferentiated process. Shiva's
wife is Parvati, beautiful yet
ascetic; but she is also Durga,
ferocious in battle, and Kali, 'the
Black One', a destroyer with an
insatiable lust for blood.
Although she is most often shown
as a horrific figure, festooned
with severed heads and limbs, in
the south she was usually shown
as a beauty, her bad habits only
hinted at by her fangs; but in this
calm and lovely work even they
are absent.

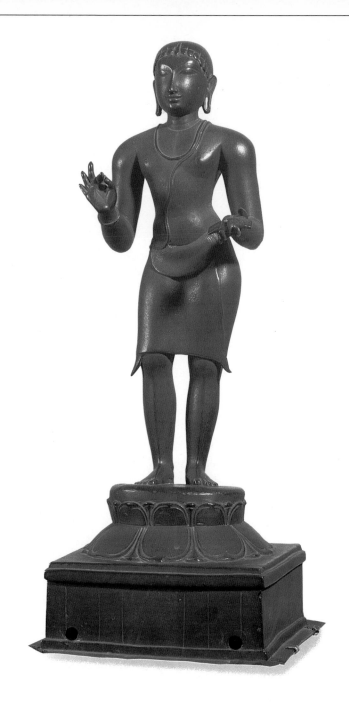

▷ **Radha and Krishna** c1550

Paint on paper

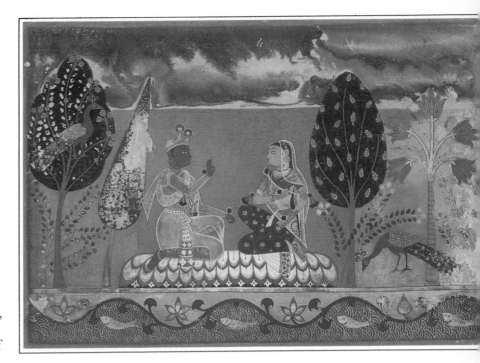

UNTIL VERY RECENT TIMES, all Indian paintings took the form of frescoes, or of miniatures done for books and albums. The earliest surviving miniatures were painted on long, narrow palm leaves, strung together and enclosed within wooden covers. Paper was not introduced until the 13th century, and only became the norm in the 15th. The painting shown here is one of a group done at Mewar, a Hindu kingdom in Rajputana (western India). It illustrates a poem, the *Gita Govinda*, which describes Krishna's amours with milkmaids, of whom the chief was Radha. Krishna, one of the best-loved Hindu gods, is always shown as blue-skinned. Despite its naïve-seeming style, this is a pleasing picture which is rather effectively laid out. The details are striking (for example the peacock and the border of fish, waves and flowers), yet most of the expected background has been eliminated in favour of flat colours, notably the bright red that focuses attention on the god and his love.

▷ **Krishna Dancing on a Snake** 16th-17th century

Bronze

THE DEVELOPMENT OF HINDU ART was severely disrupted by the Muslim invasions of the 13th century. Hindu traditions survived best in Rajputana, which produced some notable painting, and in the far south, where bronzes of a high quality continued to be made. However, the Dravidian style became increasingly decorative, and the group shown here, though fanciful and vigorous, is less poised and harmonious than earlier works. The subject comes from the boyhood of Krishna, which was spent among herders; although an incarnation of Vishnu, in his human form he needed protection from his murderous uncle, and so remained incognito until he reached maturity. Even as a boy he performed amazing feats, destroying demons, pulling up trees and, here, vanquishing the many-headed snake Kalilya. He owed his great popularity among Hindus to his reputation as a prankster, stealing the clothes of bathing girls and luring maidens to him by playing the flute; despite his fickleness and amorality, his erotic adventures were much admired.

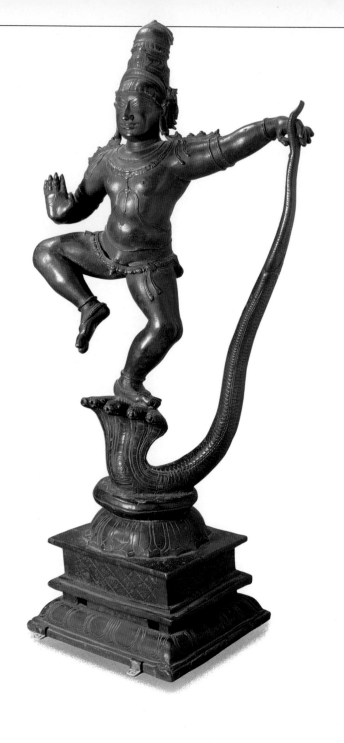

▷ **Rustam Slaying Asdiv of Mazandaran** Late 16th century

Paint on paper

THE EARLIEST MUSLIM INCURSIONS into India began in the early 8th century, when Arab armies captured the north-western region of Sind. But most of the sub-continent was unaffected until invasions starting in the late 12th century led to the establishment of a Muslim dynasty in Delhi and the importation of elements of Persian culture. These became far stronger after Babur established the Mughal empire in 1525-26. The jewel-like delicacy of Persian miniature painting was copied and modified by Indian artists, who created a new 'Indo-Persian' style. The scene shown here was painted in the Deccan, but the text is that of a Persian classic, the *Shah-Nama* by Firdusi, and the style is almost entirely Persian. The hero of this episode, Rustam, was the Persian Hercules, whose legendary exploits included this St-George-like feat, the slaying of the white monster Asdiv.

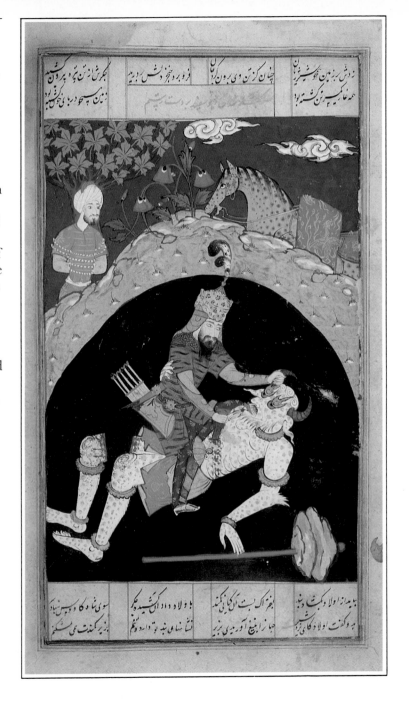

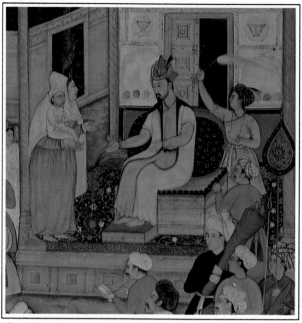

Detail

▷ **The Infant Akbar is Presented to Humayun** c1590

Paint on paper

A NEW ERA BEGAN IN 1525-26, when the Mughal leader Babur descended on India from his capital at Kabul. By the time of his death in 1530 he had conquered much of the north-west, and the Mughal empire endured and prospered despite the vicissitudes experienced by Babur's son Humayun (1530-56). At the lowest point in his career Humayun became an exile at the Persian court; and when his fortunes improved, he returned to Kabul, and eventually India, bringing with him Persian artists. Consequently, the cultural outlook of the Mughal court became Persian rather than central Asian, modified in time by native Indian influences. Humayun was obsessed by astrology, and it is said that when his son Akbar was born the child's horoscope was so propitious that the Emperor danced for joy. On this occasion the horoscope was not wrong; the scene in which Akbar is presented to his father at Kabul comes from the *Akbar-Nama*, a biography of Akbar which records all his triumphs.

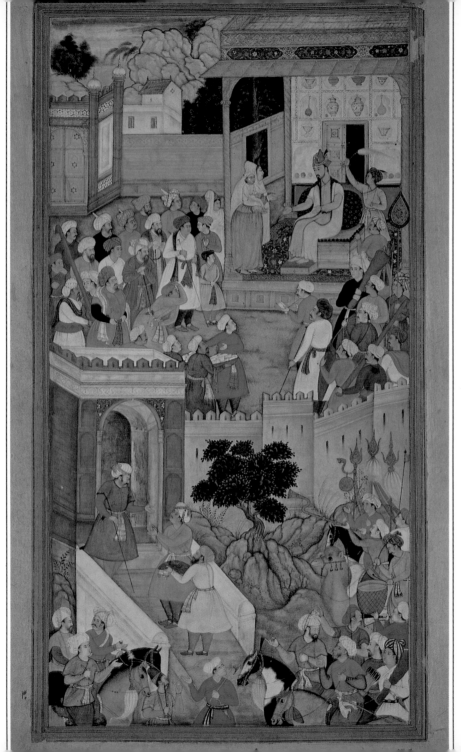

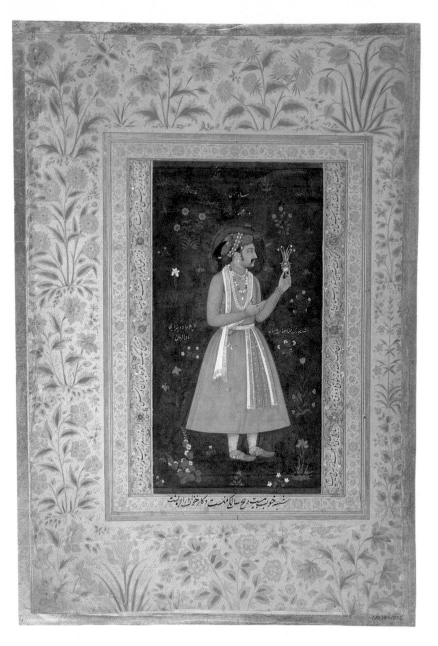

◁ **Portrait of a Man** 1589

Paint on paper

THE MUGHAL EMPERORS maintained studios in which scores of artists were employed. Thanks to the relative tolerance of the early Mughals, many of these artists were Hindus who, having absorbed Persian techniques, made their own contribution to the development of Indo-Islamic art. The court painter was, among other things, a visual historian, producing set-piece records of events and individual portraits with recognizable features (by contrast with the generalized images made of, for example, the Buddha). The painter's role was important enough for his name to be attached to one of his works, although not so important that it was done on a regular basis. This portrait is by Abul Hasan, the leading Mughal artist under Akbar and his son Jahangir. According to Jahangir, a great connoisseur, the two great artists of his own time were Abul Hasan and Mansur (one of whose works is shown on page 49).

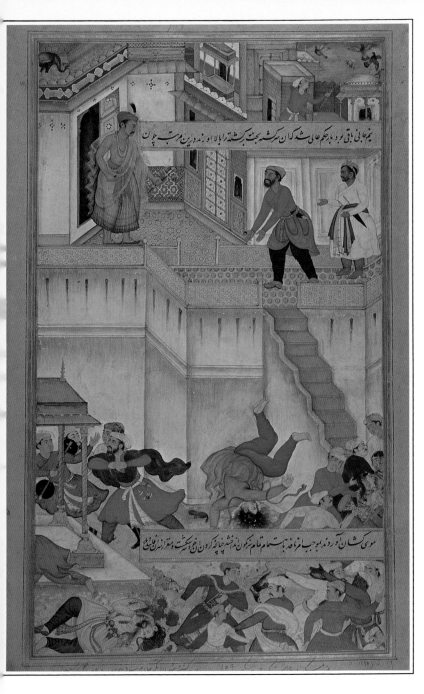

◁ **The Death of Adham Khan**
c1590

Paint on paper

ALTHOUGH THE ASTROLOGERS
had predicted greatness and good
fortune for him, the 13-year-old
Akbar had to fight hard even to
hold the throne he inherited from
his father in 1556. Akbar's greatest
assets were devotedly loyal
advisers and his own
extraordinary energy. Faced with
two rival aspirants to his throne,
he marched to war, only to hear
that a third, Himu, had seized
Delhi. Akbar returned and on the
5th November 1556 defeated
Himu at the battle of Panipat. In
the following year Akbar deposed
his two rivals and for a time
allowed himself to be ruled by his
advisers. After he took over the
reins of government in 1560, he
was faced with a final challenge
from within by his foster-brother,
Adham Khan, who murdered
Akbar's chief minister – shown
bottom left, lying in his blood –
and attempted to assassinate the
Emperor himself. Akbar fended
him off and ordered that he
should be flung headlong from
the terrace. This dramatic
moment is recorded in a miniature
from the *Akbar-Nama*.

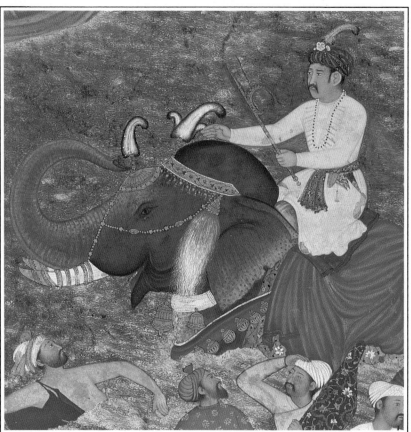

Detail

▷ **Akbar Crossing the River Ganges** c1590

Paint on paper

AKBAR (1556-1605) WAS the most remarkable of all the Mughals. During his 49-year reign he expanded his shaky north-western dominions into an empire that stretched from Persia to the Bay of Bengal. By the 1570s the Rajput kings in the west had been subdued or had prudently recognized Mughal supremacy. Within the next ten years Bengal, beyond the Ganges, had been conquered. And during the rest of Akbar's reign, Mughal expansion continued to the north and west, and south into the Deccan. Meanwhile, the Emperor's artists were kept busy recording the legends of the past and the feats of the present. Painting seemed to take on something of Akbar's own immense vitality, sacrificing the exquisite quality of the Persian tradition for a new energy and sense of action. These are very apparent in the scene from the *Akbar-Nama* in which the Emperor, his followers, and their elephants and horses force their way across the Ganges.

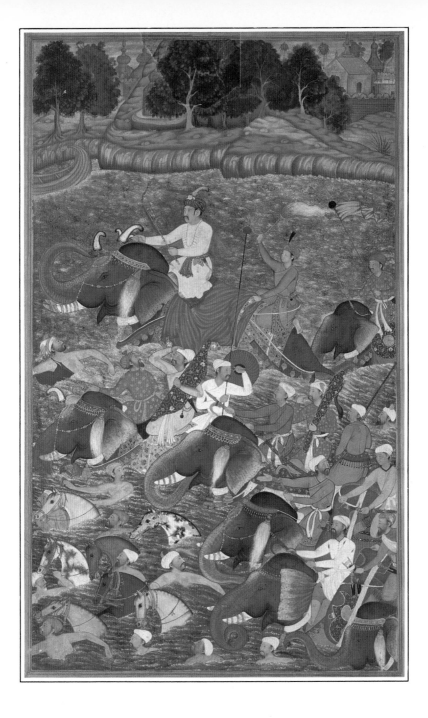

Detail

▷ **Building the Red Fort** c1590

Paint on paper

AKBAR WAS A GREAT BUILDER, tackling current projects with characteristic vigour and instigating new ones, in new places, with something of the restlessness of his nomad forebears. Among his most impressive monuments are the city of Fatehpur Sikri and the Red Fort at Agra. 'Fort' hardly describes this huge palace-complex-cum-castle, standing 21 metres (69 feet) high and protected by walls two km (1.2 miles) long and a ditch 10 metres (33 feet) deep. Painting is our prime source of information about everyday life in Mughal times, and this illustration from the *Akbar-Nama* shows a range of building activities, so zealously pursued that we can be certain that the workmen were well aware of the artist's presence. Everybody is busily employed weighing, knocking, nailing, carrying materials up ramps, and laying the stones and mortar; meanwhile, fresh building supplies are arriving by water and in a cart being drawn by a rather undernourished-looking bullock.

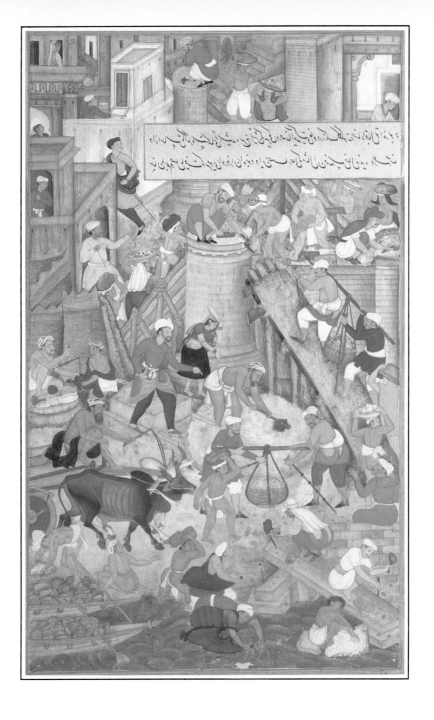

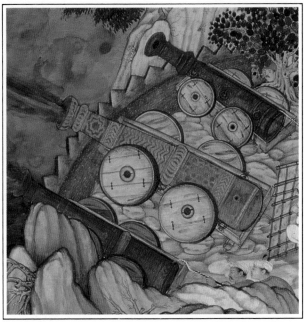

Detail

▷ **A Siege in Progress** c1590

Paint on paper

THIS THRILLING, VERTIGINOUS battle-piece from the *Akbar-Nama* conveys the heat and haste of action in masterly fashion: the rugged terrain, the press of men urging on the bullocks as they haul the big siege-gun into position, the babble of voices, beating of drums and roar of the artillery. Two of the gunners crouch behind a screen, presumably to protect themselves from the effects of the most powerful cannon. In the midst of all this furious activity, the artist has rather cheekily placed a few birds and beasts who seem to be interested spectators, rather implausibly unabashed by the turmoil; one, quite close to the guns, is a mountain goat. Akbar's men are besieging the Rajput town of Ranthambhor, whose commander surrendered to the Emperor on generous terms, so that this was in reality one of the Mughals's less bloodthirsty operations.

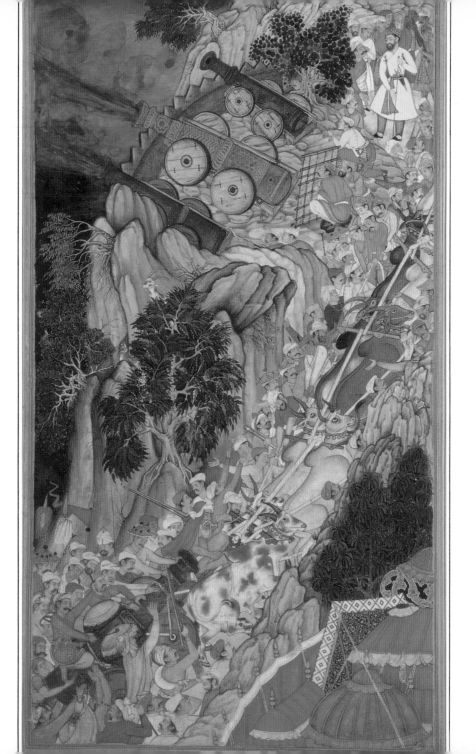

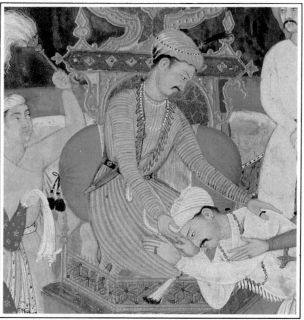

Detail

▷ **Surjam Hada Submitting to Akbar** c1590

Paint on paper

HERE IS THE GREAT AKBAR in all his glory – in the field, enjoying another triumph, but also at his ease in a tent like a canopied open-air palace. The state which the emperors kept in wartime is also hinted at in the corner of *A Siege in Progress* (page 42). Like their nomad ancestors, the Mughals travelled to war with an entourage, but one which their imperial status had caused to swell to the size of a second army. The scene shows the Mughal artist's delight in picturing throngs of people and gorgeously decorated fabrics and carpeting; and for good measure there is a townscape with a procession of horsemen leaving from the main gate. Akbar, the patron of poets and painters, never learned to read and write, but used others as his instruments. Painters followed his instructions, and his biography, the *Akbar-Nama*, if not actually dictated to its author, the minister Abul Fazl, certainly provides a faithful reflection of the Emperor's self-image.

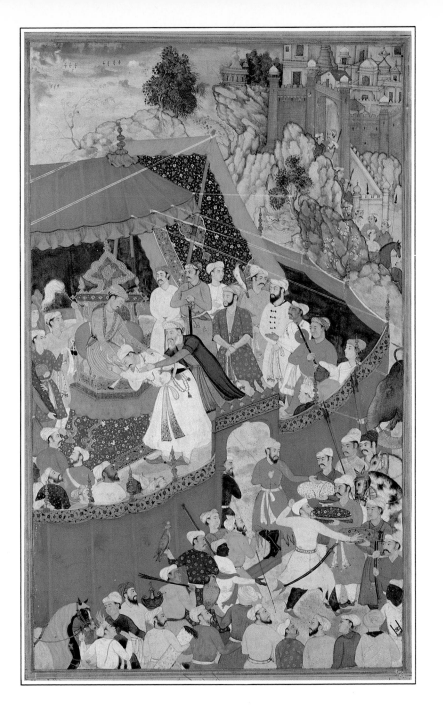

▷ **Prince Salim Surprised by a Lion** c1595-1600

Paint on paper

PRINCE SALIM, AKBAR'S ELDEST SON, is out hunting when a lion, with unusual temerity, suddenly attacks him, despite the fact that he is seated high on the back of an elephant. The Prince reacts courageously (at any rate in this picture by a court artist), defending himself with the butt of his rifle. Apart from the very precise rectangular rip made by the lion in the elephant's fabric covering, the scene is extremely convincing, showing once again that Akbar's artists were masters at combining colourful decoration and pattern-making with vigorous human drama. Salim became increasingly impatient to replace his ageing father, only drawing back on the brink of outright rebellion when challenged by Akbar's minister (and biographer), Abul Fazl – whom Salim then arranged to have assassinated. Fortunately for him, he was Akbar's only possible successor, since his brother was a chronic alcoholic who died in 1604. The following year, Salim succeeded his father as emperor, taking the name Jahangir, 'World-Seizer'.

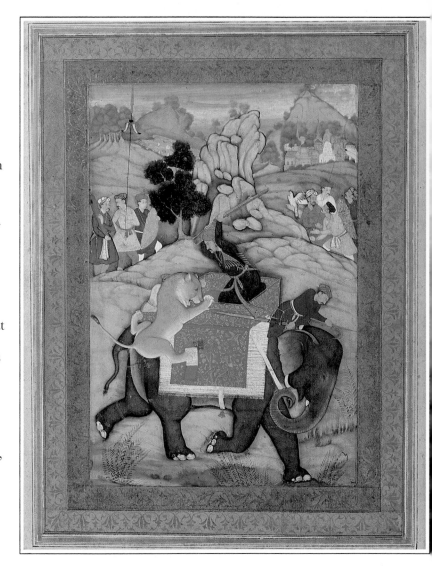

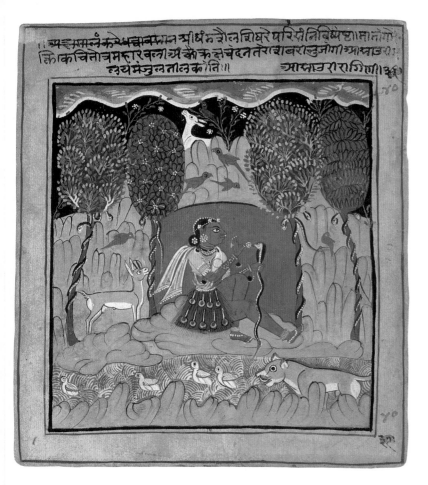

◁ **Asaveri with a Cobra**
1605

Paint on paper

THIS MINIATURE FROM Udaypur in Rajasthan shows the persistence of the Hindu painting tradition, and is in the starkest possible contrast to contemporary works by Mughal artists. Its purpose – the illustration of a musical mode – highlights the close links between Hindu art, music and poetry. Indian musical scales consist of *ragas* and *raginis*, which are conceived of as male and female. They are also associated with colour values and with states of mind or situations. Medieval Indian poets composed series of poems, called *ragamalas*, describing these situations, and painters in turn illustrated the poems. The heroine of this painted *ragamala* is Asaveri, whom the poet pictures 'with shining dark skin, adorned with peacock feathers and a necklace of rare, splendid pearls'. Seated on a mountain top, she has dragged a snake from its hole and is about to use it as a girdle. Although so highly stylized that it is almost cartoon-like, this is a very lively picture.

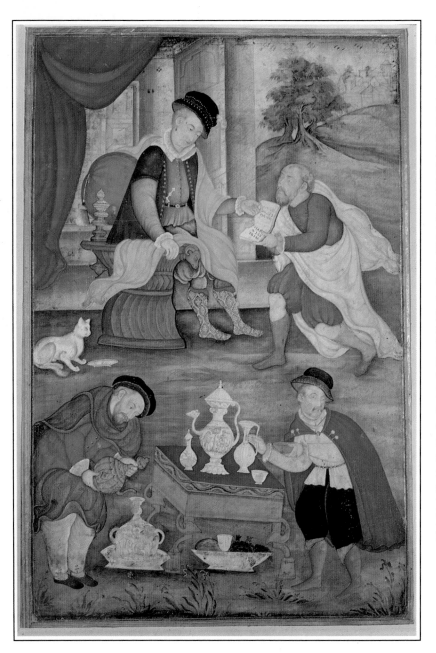

◁ A European and His Servants c1605

Paint on paper

MOST HUMAN CULTURES have found outsiders faintly ridiculous, or menacing, or both. The Mughal artist's view of Europeans is, all things considered, quite a kindly one, although the bent knees and rounded backs of the servants – servility in the European style – evidently struck him as worth emphasizing. The naïve air of the painting contrasts strongly with the confidence of contemporary Mughal art, possibly indicating that the subject matter was still too unfamiliar to be treated with real assurance; many of the details suggest that the artist was basing his work on a European original – perhaps an engraving – rather than direct observation. The Portuguese navigator Vasco da Gama and his crew were the first Europeans to reach India by sea, landing at Calicut in 1498; but the earliest European contacts with the Mughals in the north occurred later, in the 1570s.

▷ **A Jesuit** 1610

Paint on paper

AMONG THE EARLIEST EUROPEANS
to reach the Mughal empire were
Jesuit missionaries, sent from the
Portuguese enclave at Goa at the
request of the Emperor Akbar.
They arrived at Fatehpur Sikri 'to
convert the inhabitants', but found
that the Emperor, though deeply
interested in religion, was not
necessarily inclined to accept any
single creed as the final truth. His
attitude disconcerted the
missionaries, who seem to have
been more angered by Akbar's
open-mindedness than they might
have been by obstinate opposition;
nevertheless there were new
missions during the 1590s. This
portrait is far more natural than
the painting of Europeans
(opposite), perhaps only because
the artist was more talented. In
this instance he was Mansur,
whom the Emperor Jahangir went
so far as to call 'the Wonder of the
Age'; and he has certainly shown
the Jesuit, not as an oddity, but as
he might have seen himself.
Everything from the skin tones to
the rosary is well observed, so no
doubt the foreigner really did at
least yield to Indian custom in the
matter of his footwear.

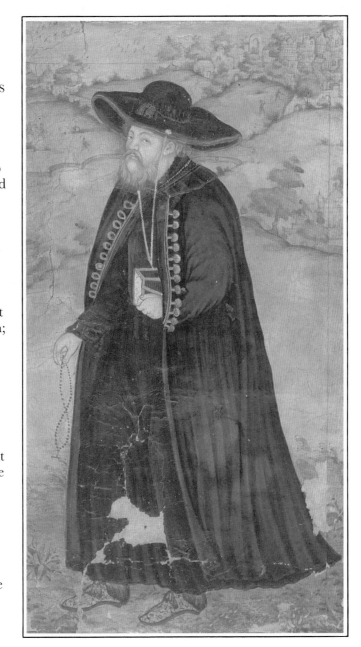

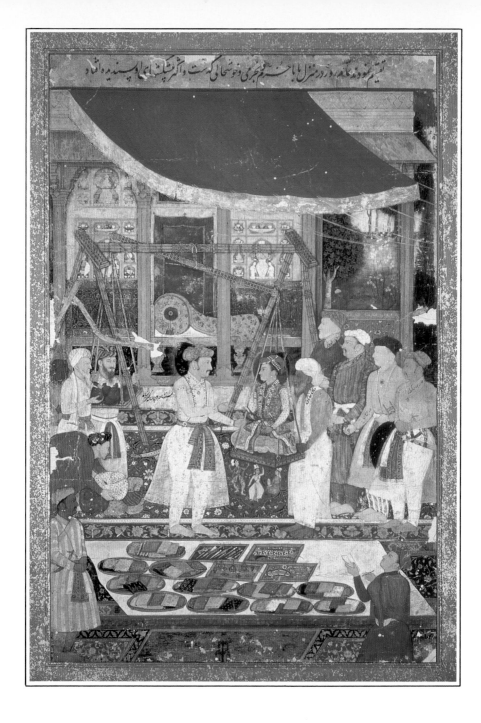

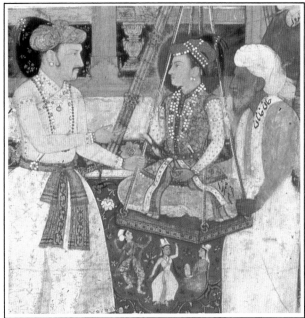

Detail

◁ **The Weighing of Prince Khurram** c1615

Paint on paper

THIS PAINTING GIVES US a direct entrée into the Mughal court at the height of its splendour. It is alive with opulent details, including the cabinet at the back, filled with objects that look like porcelains and other imports from China. At the same time, the canopy and garden, real or imaginary, give the scene an open-air feeling which the Mughals seem always to have valued, presumably as a memory of their nomad origins. The miniature illustrates an episode, recorded in the memoirs of the Emperor Jahangir, which can be dated to 1607. Warned by his astrologers that a crucial period was at hand, and recalling that his son Khurram had been in poor health, Jahangir ordered that on his 16th birthday the boy should be weighed against quantities of gold and other precious metals, which were then distributed among holy men and the poor. Khurram survived to become the Emperor Shah Jahan (page 52).

▷ **Shah Jahan** 18th century

Paint on paper

THIS IS A LATE 18TH-CENTURY
copy of a painting done during the
reign of Shah Jahan (1628-58).
Although it may well be a good
likeness, the impression of the
Emperor it conveys could hardly
be more idealized. He is pictured
with a flower in one hand, sitting
in a kind of miniature pavilion
which is open to the air. The floral
patterns are exquisite and, as so
often, the calligraphy is beautiful
in its own right and fully
integrated into the overall design.
In reality, Shah Jahan was as
capable of excess as any of his
ancestors or descendants,
rebelling against his father and
murdering a number of relatives –
including his own brother – in
order to secure the throne. During
his reign Mughal power showed
signs of waning, and a Muslim
reaction began against the wise
religious tolerance of Akbar and
Jahangir. By contrast, Mughal
painting remained as skilful as
ever, although it has been argued
that its very perfection
represented a dead end.

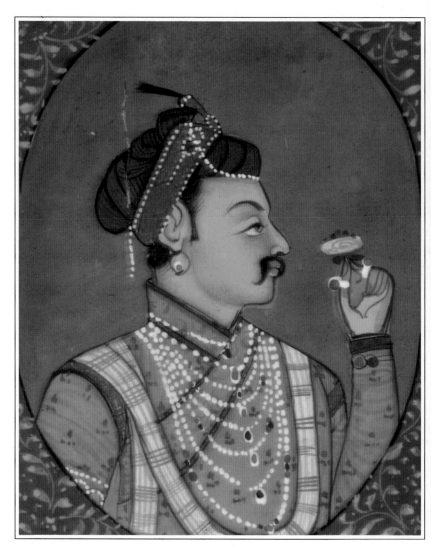

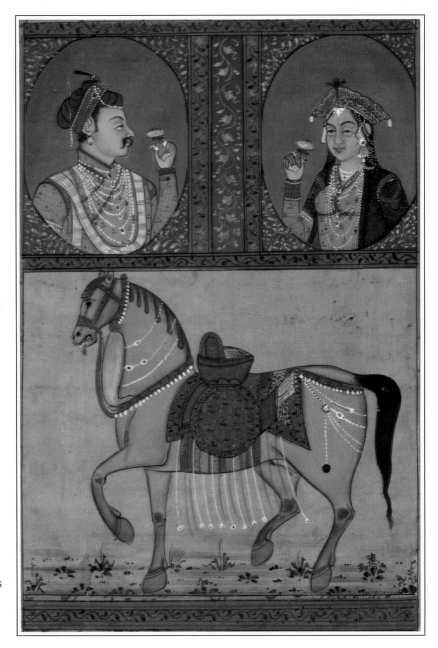

▷ **Shah Jahan and Mumtaz Mahal**

Paint on paper

THIS UNDATED MINIATURE SHOWS the Mughal emperor Shah Jahan and his favourite wife, Mumtaz Mahal. The Mughals were far from being faithful husbands, and they also exercised their legal right to be polygamists, if only because marriage was, among other things, a useful diplomatic device for cementing alliances. But they were nevertheless capable of strong attachments, and Jahangir's queen, Nur Jahan, had such a hold over him that she was able to exercise effective political power during his later years. Mumtaz Mahal had a less spectacular career, but on her death in 1632, giving birth to her 14th child, Shah Jahan built her the most famous of all mausolea, the Taj Mahal (page 55). Legend pictures the emperor, imprisoned by his own son during the last eight years of his life, as gazing mournfully from the Red Fort at Agra on the tomb of his beloved wife.

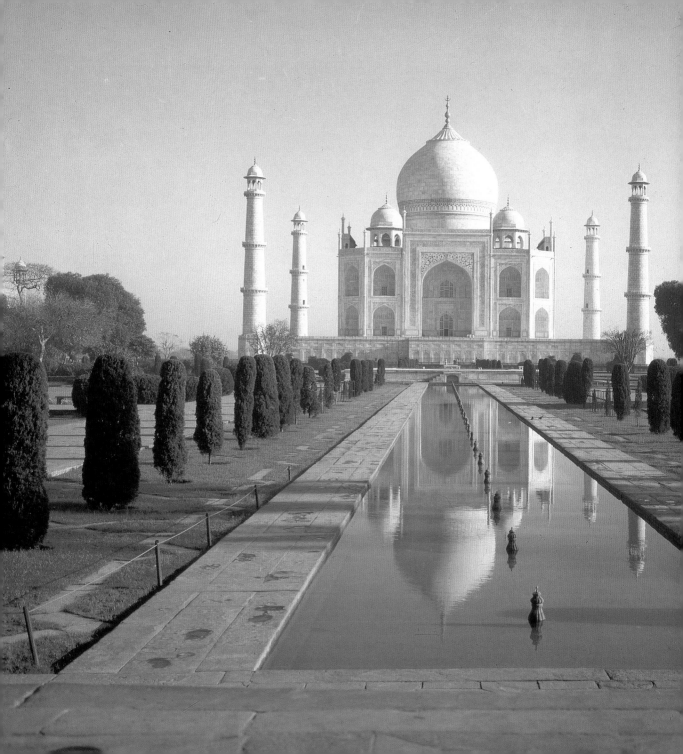

◁ **The Taj Mahal** 1632-54

THE WORLD-FAMOUS TAJ MAHAL is actually a mausoleum, built at Agra by the Mughal emperor Shah Jahan for his favourite wife, Mumtaz Mahal ('Jewel of the Palace'), who died in 1632. The main structure was probably complete within four or five years, but the entire scheme took over 20 years. In essentials, the Taj Mahal is an octagonal building crowned with an onion dome and extending on its platform to four corner minarets. Its plan was not new, but was based on the tomb of Shah Jahan's great-grandfather, Humayun. The dramatic difference lay in the lavish use of a dazzling white marble facing, which lightened and lifted the building, giving it a dream-like quality in spite of its immense size. The Jumna River flows on one side of the Taj Mahal; the main facade lies behind the lovely formal garden, broken by water-courses, which is perhaps a vital element in the sense of enchantment which generations of visitors have experienced at this spot.

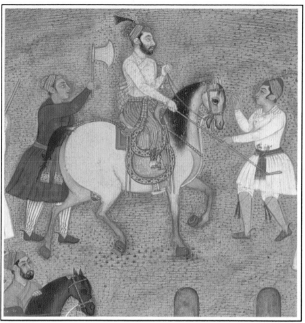

Detail

▷ **A Polo Match** Mid-17th century

Paint on paper

OUR KNOWLEDGE OF EVERYDAY LIFE in India is deficient in many respects, in part because so much Hindu and Buddhist art was created for exclusively religious purposes. Fortunately Mughal attitudes were quite different: the emperors delighted in the pageantry and pleasures of their lives, and in seeing them recorded for posterity. Though limited by the fact that it is a court art, the Mughal miniature gives us a lively picture of the age. The artist who painted this scene was interested in all its incidents – not just the aristocrats at play on splendid mounts, but also the servants bringing fresh sticks and the player being cooled off with a fan. Polo originated in Central Asia as a mimic battle; Muslim invaders introduced it to India, and by Mughal times it had become a civilized, aristocratic pastime. Later, in the 1860s, British planters and officers in India took it up, and by the 1880s it had become an international competitive sport.

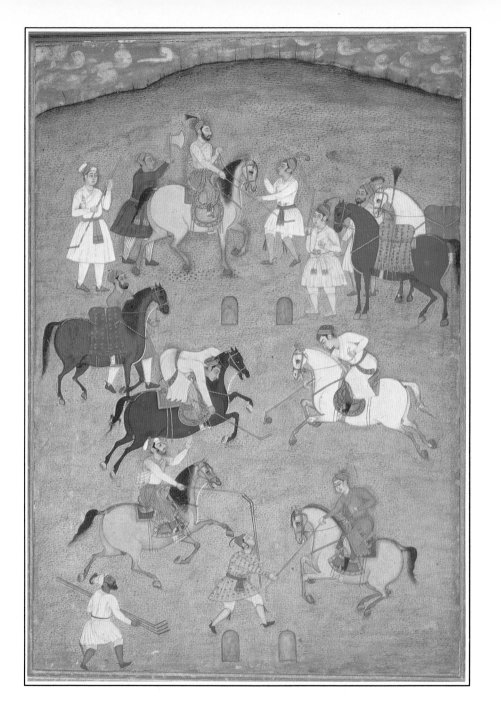

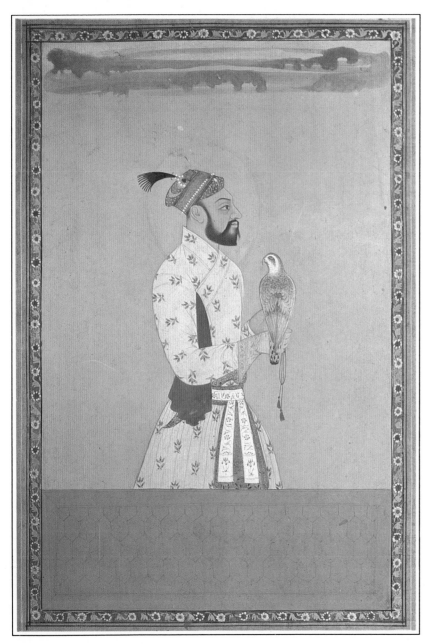

◁ **Muhammad Azam** c1680

Paint on paper

MUHAMMAD AZAM (1653-1707) was the third son of the puritanical Mughal emperor Aurangzeb. The Emperor shut down the royal workshops which had produced so many superb miniature paintings, and the scores of artists who had been employed in them had to seek work at other Indian courts. Consequently their dispersal did not bring the Mughal artistic tradition to an abrupt end, although it was inevitably weakened in the long run. This portrait of Muhammad Azam holding a falcon is as fine as any Mughal miniature, but it was painted in the Deccan, an area of central India that Aurangzeb occupied but never managed to pacify; in fact the emperor's obsessive and ruinously expensive efforts to suppress one Deccani revolt after another were the main reason for the rapid decline of Mughal power after his death in 1707. One of the victims in the battles for the succession was Muhammad Azam, who perished at the hands of his brother, Bahadur Shah.

▷ **Aurangzeb at Prayer**

Paint on paper

LIKE HIS FATHER AND
GRANDFATHER, Aurangzeb waded
through the blood of his brothers
and relations in order to become
Mughal emperor; unlike them, he
took power before the death of his
father, Shah Jahan, who spent his
final years (1658-66) in prison. But
as emperor, Aurangzeb soon
became a pillar of Muslim
orthodoxy, encouraging the trend
towards the persecution of
Hindus; despite the military
successes he achieved during his
lifetime, his reign alienated the
majority of the Indian population
and fatally weakened the fabric of
Mughal society. His influence on
painting was equally negative,
since he patronized the arts for
only a few years before becoming
convinced that the representation
of human beings was against
Islamic law. So there is a
paradoxical appropriateness in
this 'sinful' yet pious image of the
emperor, his sword beside him and
a fly-whisk in his hand, kneeling
on his prayer mat.

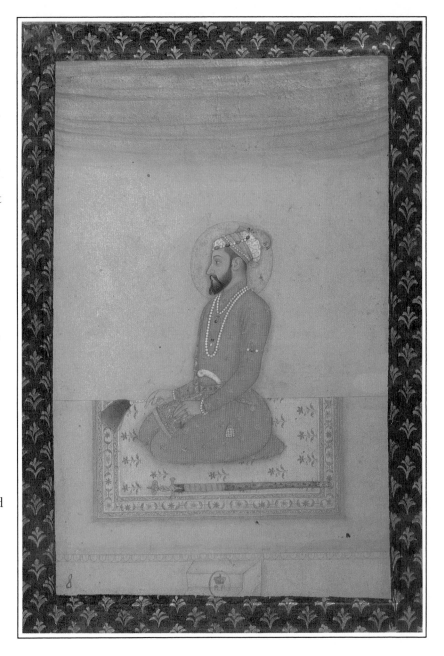

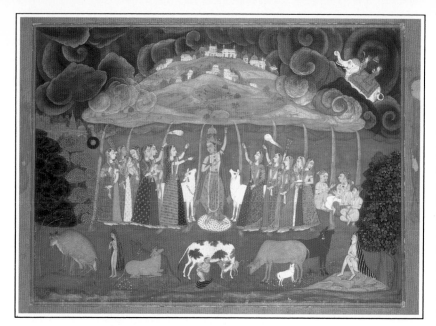

△ **Krishna Holding up Mount Govardhan** c1690

Paint on paper

THIS ILLUSTRATES A very well-known Hindu myth which, like many myths, preserves the memory of a real historical event. In this instance the event was the dethronement of Indra, along with other ancient Vedic gods worshipped by the Aryans, in favour of Vishnu-Krishna and the other deities of an evolving Hinduism. The myth relates that the sky god Indra became angry with his former worshippers when they began to sacrifice to Krishna.

Indra unleashed a terrible storm on them, but Krishna effortlessly raised the mountain, using it as an umbrella to shield his followers; and Indra was compelled to admit his rival's superiority. The miniature was painted in the western desert state of Bikaner, whose artists were influenced by the Mughal school but nevertheless produced distinctive work of their own. The details – especially the cow giving birth – are both curious and charming.

▷ **Swimming to a Lover**
18th century

Paint on paper

WITH THE DECLINE OF THE Muslim Mughal empire, provincial rulers, mostly Hindu, were able to assert their political and artistic independence. A variety of schools of painting sprang up in the Rajput kingdoms of the west, and also in the numerous Punjab Hills states much further north. This painting from Rajasthan has a curious, rather quirky air. The man, having laid aside his shoes and weapons, plays the pipes abstractedly, apparently unaware of any possible consequences. The woman breasts the stream as if in a trance, perhaps drawn by the music rather than by the sight of her lover: Hindus who looked at the picture would certainly be reminded of the exploits of the god Krishna, whose fluting made him irresistible to women. It may be significant that the seated ascetic in the foreground is painted blue, like Krishna himself in Indian paintings. The picture is full of delightful natural details, well worth close scrutiny.

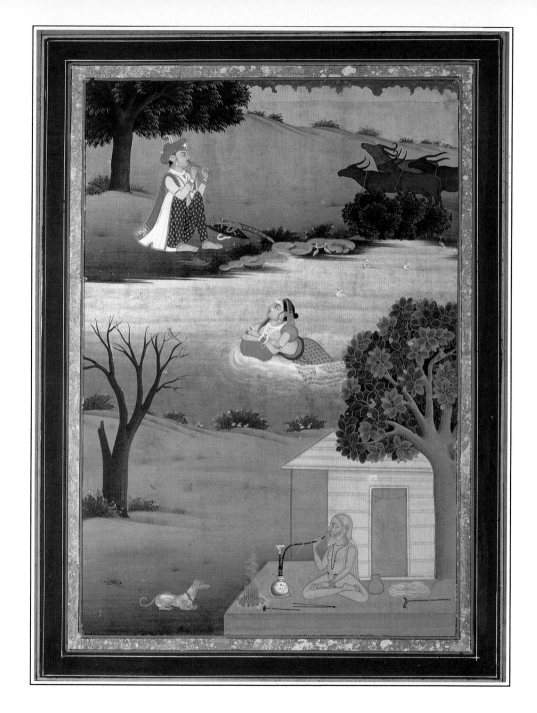

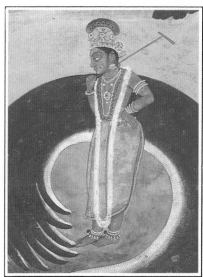

Detail

▷ **The Submission of Kaliya** First half of the 18th century

Paint on paper

LATE IN THE 17TH CENTURY, schools of miniature painting developed for the first time at a number of centres in the Punjab Hills. The style was known as Pahari, and the ever-popular adventures of Krishna provided much of the subject matter, as in this painting from the state of Basohli. It shows Krishna in his moment of triumph over Kaliya, the king of the snake deities, after a struggle which the god won by dancing on the hooded head of his opponent. The wives of Kaliya are also worshipping Krishna. This was one of the god's bloodless victories, for, once vanquished, the snakes became his loyal devotees. The incident is still celebrated every year at the Nagapanchami festival, when paintings like this one (though in cheaper, more disposable versions) are put on public display to protect their owners from the unwelcome attentions of snakes.

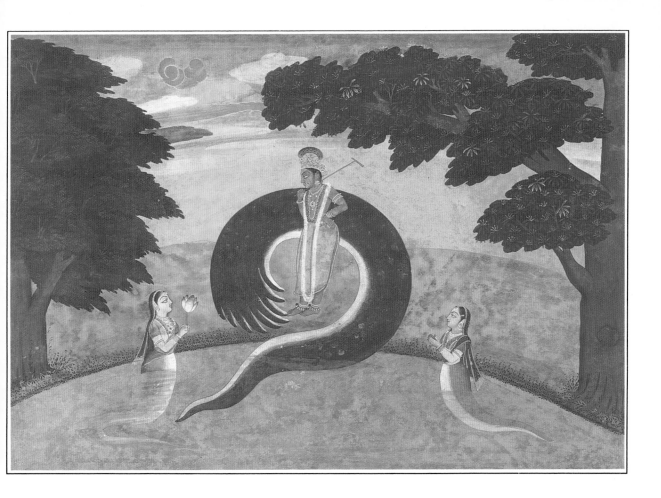

Detail

▷ **A Lady Waiting for her Lover** c1760

Paint on paper

This is an unusually potent mood painting from the Punjab Hills school in the north-west. The subject illustrates the abiding Indian interest in the arts and incidents of love, manifested in the early centuries AD by the celebrated *Kama Sutra*, which was itself said to be a mere abridgement of a much earlier work. Here, the lady's feelings about her absent lover are conveyed not only by her expression and attitude, but most poignantly by the brilliant touches of red on her lips and nails, emphasizing the care with which she has prepared herself for his coming. Evidently he is long overdue, for although the lady is wide awake, her maid has fallen asleep and seems to be having agreeable dreams. The thunder and lightning are rendered in a sketchy, dramatic style that makes an effective contrast with the still, sorrowful atmosphere of the scene below.

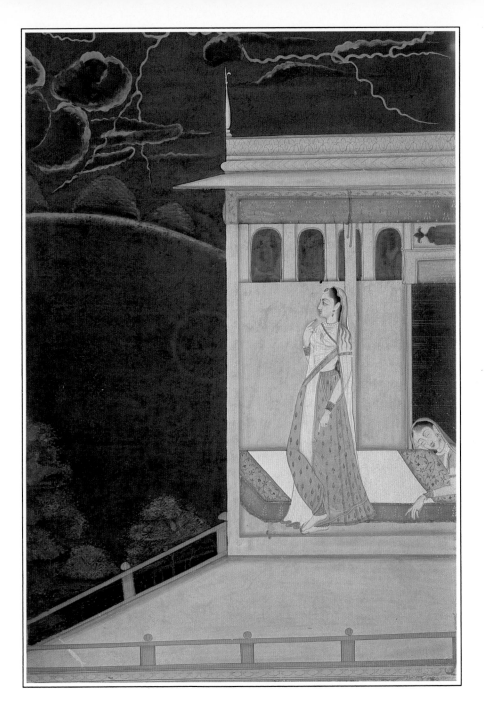

Detail

▷ **Durga in Combat** 1750

Paint on paper

THIS SCENE IS AN INTERESTING example of what could happen when Mughal influences were brought to bear on traditional Hindu culture, represented by a miniature painting from the Rajput state of Bikaner. The subject is the battle between the goddess Durga and the demon Mahishasura. Durga's name signifies 'she who is difficult to contend with', and she is the battle-seeking incarnation of Parvati, wife of the great god Shiva. Durga's ten arms have been reduced to a more manageable four, and she is painted in a refined style derived from Mughal art. Her most striking gesture is hieratic rather than warlike, although in her other three hands she carries a dagger, a sword and a lance in the form of a snake. Mahishasura, however, is a fanged, eight-armed demon in the traditional mould, snarling defiance despite the fact that his steed is succumbing to Durga's lion mount. The indispensable gore is provided by the decapitated warrior on the ground.

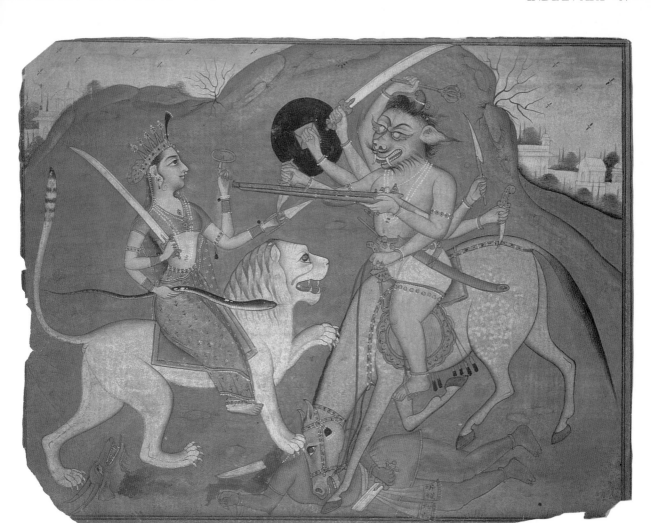

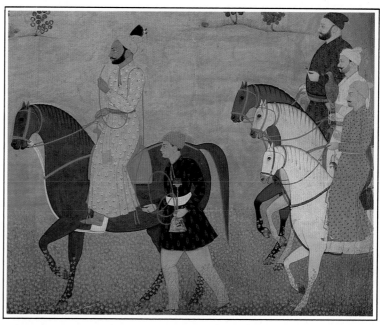

Detail

▷ **A Prince Out Riding** c1751

Paint on paper

THIS MINIATURE WAS PAINTED in the northern Punjab state of Jammu, and probably portrays the Raja Balwant Singh. The artist was Nainsukh (active 1740-51), who certainly produced a number of portraits of Balwant Singh; his figures tended to be small, as here, and sometimes minuscule. In one curious picture, the rajah is a tiny figure standing on the formidably high walls of his palace, which occupy almost the entire available space. Like the Mughals, Bulwant Singh evidently believed in taking his pleasures with him wherever he went, for apart from his falcon and huntsman he is accompanied by musicians, a servant to carry the hukka which he smokes even on the move, and some feminine company. The riders make their way through a delightful carpet of flowers, in a landscape with strangely schematized vegetation. The rather faint figures of retainers and dogs stand in the distance, and the vivid red of sun-inflamed clouds can just be glimpsed over the line of the hills.

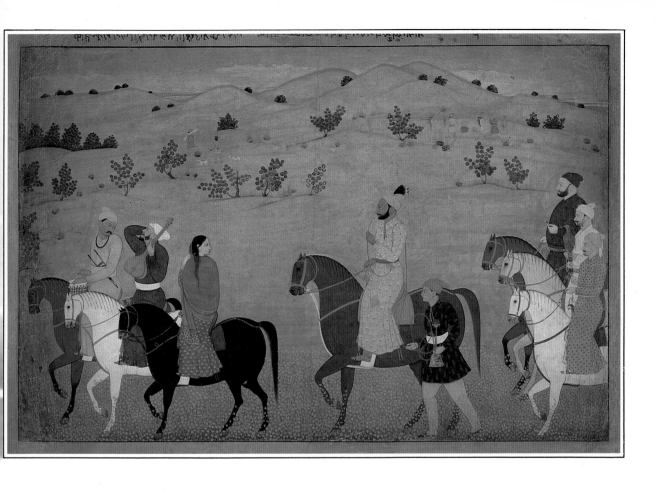

Detail

▷ **Celebrating the Festival of Holi** c1780

Paint on paper

ONE OF THE LEADING ARTISTIC CENTRES among the Punjab Hill states was Guler. Its position, not far from the plains and the imperial court, ensured that Mughal influences were quickly absorbed, and that unemployed Mughal artists were warmly received. Consequently Guler miniatures became well-known for their refinement, while maintaining a characteristic Hindu boldness and vigour. Chaos appears to prevail in the painting shown here; but it is a cleverly composed chaos. Holi, the spring festival, is being celebrated to the music of drums, horns, strings and tambourine. In traditional fashion, the merrymakers are flinging red powder from a large tub over one another, and using bamboo syringes to squirt water all over the place. In this instance, the participants are the blue-skinned god Krishna, his favourite Radha, and assorted enticing ladies. Although slightly damaged, this is one of the most lively representations we have of everyday life among Hindus two centuries ago.

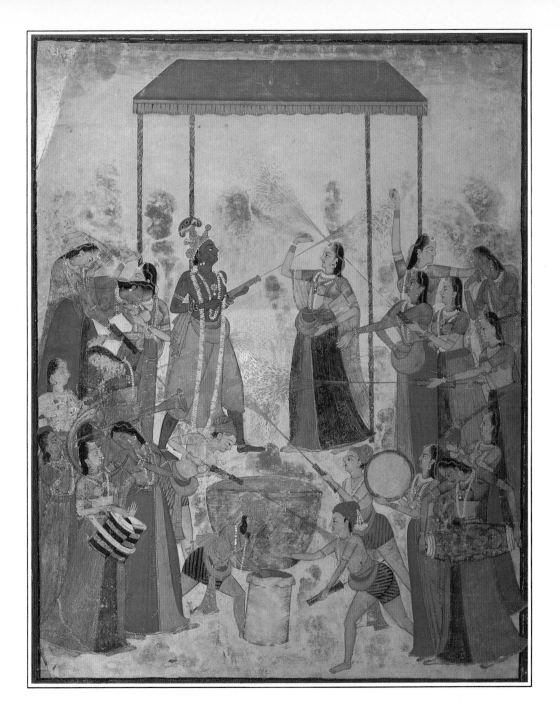

Detail

▷ **The Search for Sita** 1780

Paint on paper

THE SCENES IN THIS miniature painting from Kangra illustrate episodes from the *Ramayana*, one of two ancient Indian epics (the other is the *Mahabarhata*) dating back over 2000 years. The main story-line in the *Ramayana* concerns the wanderings of Rama, his wife Sita, and Rama's brother, Lakshmana. Denied his rightful position as king of Ayodhya, Rama leads his companions to a forest refuge. When he rejects the advances of a female demon, her vengeful brother, Ravana, king of Lanka, carries off Sita, who is only found after many adventures and much help from the monkey king Hanuman and other animal allies. The painting is an example of continuous representation – that is, a narrative with several episodes shown in a single picture. Though now unfamiliar, it was common in western painting until quite late in the Renaissance. Where the episodes are thematic – like the search going on in this picture – the device can be very effective.

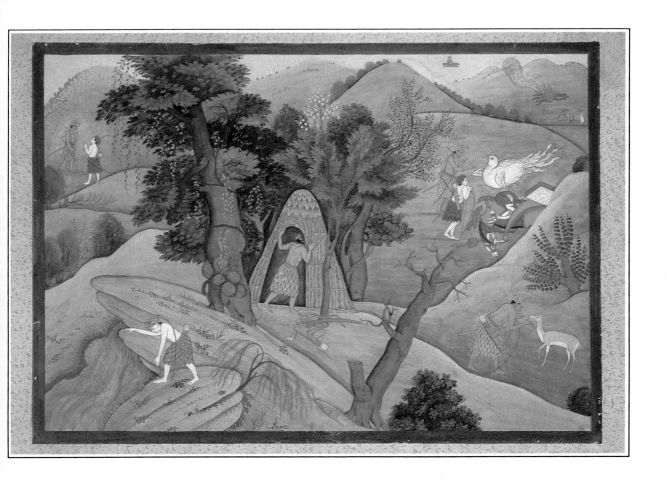

▷ **Krishna Adorning Radha's Breast** c1780

Paint on paper

THE LEADING PUNJAB HILLS SCHOOL between about 1775 and 1825 was at Kangra, where the rajah, Sansar Chand, was a passionate lover of painting. Under his generous patronage, the Kangra painters developed an intensely poetic style that imbued the traditional subjects, mainly taken from the life of Krishna, with a new romantic appeal, especially when they were set in lovely landscapes. The story of Krishna and the milkmaid Radha was a perennial favourite, bringing with it an illicit thrill, since Radha was a married woman who abandoned her husband for Krishna, despite his notorious fickleness. Like most such stories, the amours of Krishna can be interpreted in symbolic terms, culminating in union with the divine, when the god's generosity with his favours appears in another light; but it can be questioned whether symbolism was uppermost in the minds of Indian painters. Here, the intimacy of the lovers stands out against the wide landscape with its distant view of a city.

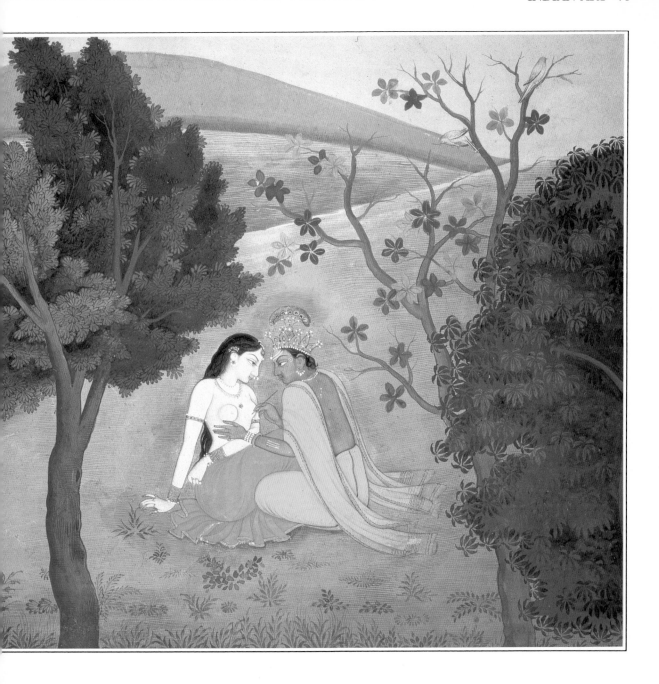

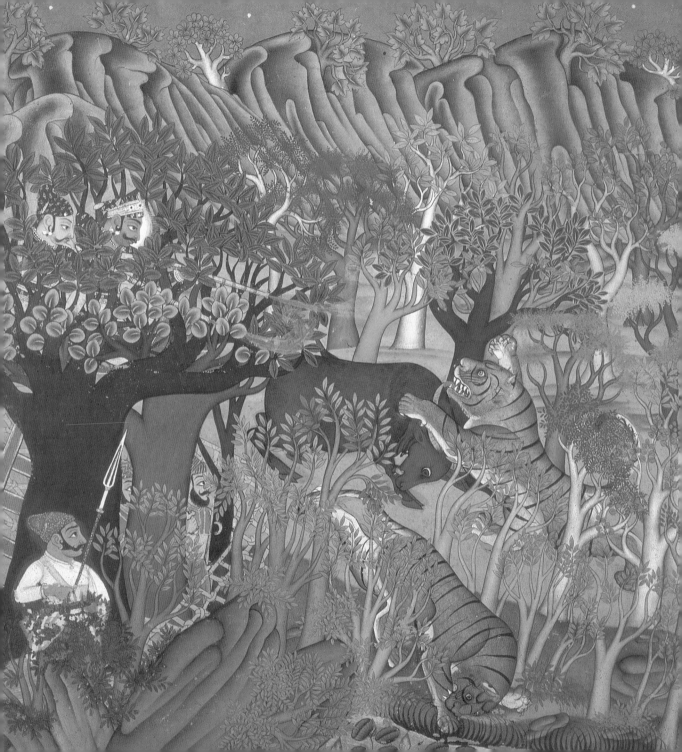

◁ **Shooting Tigers** c1790

Paint on paper

THE STATE OF KOTAH, in the Punjab Hills, produced a distinctive school of artists, notable for their renderings of animals, hunting scenes and landscapes. As in this miniature, the style was hard and clear-cut almost to the point of caricature, showing an obsessive interest in detail and creating strange, rhythmic forms such as the rock formations along the upper edge of the picture. The result has been convincingly likened to the paintings of the French 'primitive' painter, the Douanier Rousseau (1844-1910). Here, on a moonlit night, Rajah Umed Singh and his chief minister, Zalim Singh, are ensconced in a tree-hide above a clearing; a tiger is attacking the buffalo tethered there to attract it, and the two men are firing with their long muskets. The depiction of such a scene, featuring real people, indicates the presence of strong Mughal or western influence.

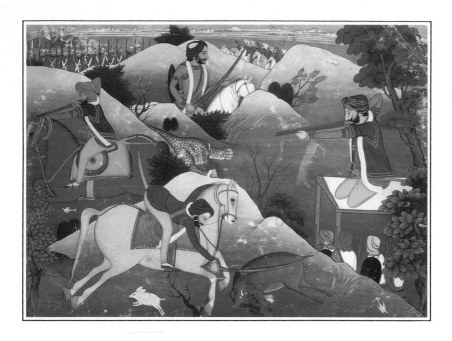

△ **A Sikh Prince Hunting** 1830-40

Paint on paper

BY ABOUT 1820 IT WAS becoming clear that the British would be the new paramount power in India. Coincidentally or otherwise, the tradition of miniature painting was losing most of its vitality, although a few centres such as Kangra would turn out good-quality work for a little longer. Meanwhile the warlike Sikhs moved into the Punjab, acquired a taste for painting, and for a time produced miniatures that expressed a definite vigour. This hunting scene is a kind of composite, featuring several activities simultaneously: a leopard-shoot from a raised platform, a boar hunt on horseback, and a chase whose climax will probably take place off the page. Despite European influences on the style of the painting, rank rather than realism determines the way in which it is organized: although their figures overlap, the hunters are all the same size (and therefore effectively in the same plane), whereas an exaggerated perspective shrinks the ranks of soldier-retainers into rows of tiny toys.

ACKNOWLEDGEMENTS

The publisher would like to thank the following for their kind permission to reproduce the paintings in this book:

Bridgeman Art Library, London/National Museum of India, New Delhi: 8, 9, 10, 11, 13, 14, 17, *18*, 19, 20, 21, 25, *26*, 27, *28*, 29, 30, 31, 33, 49, *66*, 67, *72*, 73, 78; /**British Museum, London**: 12, 24, *34*, 35; /**Museo de Muttra, India/Index, Barcelona**: 15; /**British Library, London**: *22*, 23, 48, 50, *51*, 60; /**Victoria and Albert Museum, London**: 32, 36, 37, *38*, 39, *40*, 41, *42*, 43, *44*, 45, 47, *56*, 57, 58, 61, *62*, 63, *64*, 65, *68*, 69, *70*, 71, 76-77; /**Christie's, London**: 46; /**Private Collection**: 52 *(also used on front cover, back cover detail and half-title page detail)*, 74-75; /**Bridgeman Art Library, London**: 54-55; /**Bibliotheque Nationale, Paris**: 59;

NB: Numbers shown in italics indicate a picture detail.

Every effort has been made to trace the copyright holders and we apologise in advance for any unintentional omissions. We would be pleased to insert the appropriate acknowledgement in any subsequent edition of this publication.